# Coloring Flower Mandalas

## 30 Hand-Drawn Designs for Mindful Relaxation

Wendy Piersall

Ulysses Press

*For my mother*
❀❀❀

Published by
Ulysses Press
P.O. Box 3440
Berkeley, CA 94703
www.ulyssespress.com

ISBN: 978-1-61243-457-5

Printed in Canada by Marquis Book Printing

10 9 8 7 6 5 4

Acquisitions editor: Kelly Reed
Managing editor: Claire Chun
Front cover design: what!design@whatweb.com

Distributed by Publishers Group West

# Introduction

When I published my first coloring book with Ulysses Press, *Coloring Animal Mandalas*, I assumed that this would be a zero-instructions-needed kind of book. It's coloring! Who hasn't colored before?! To my utter surprise, *how to color* in coloring books has been THE most-asked question I have gotten as a coloring book artist. I realized that most adults haven't colored in 20+ years (or sometimes 60–70+ years!). Also, when you're coloring as an adult, crayons just don't cut it anymore. We want a great experience and want to use great, grown-up materials. And we want gorgeous, beautiful results that we can hang on our walls when we are finished!

When choosing which colors to use, remember there is no wrong way to do it. Go with a rainbow spectrum, or just pick a color and let the spirit of spontaneity take over. I personally recommend using colored pencils to fill in the tiny spaces of adult coloring books. Try coloring with your favorite music in the background and get into the zone when you know you won't be interrupted for at least 30 minutes. For more in-depth tips on coloring, go to WendyPiersall.com/how-to-color.

Additionally, there were a few beautiful flower mandalas that didn't make it into this final printed book. You can download these coloring pages for free as a bonus for purchasing this book at WendyPiersall.com.

Lastly, I truly enjoy seeing friends and fans color my art and post them on their blogs and on social media. Please join our coloring community by sharing your work on Instagram and tagging your photos with #coloringflowermandalas or on Facebook at Facebook.com/WendyPiersallArt!

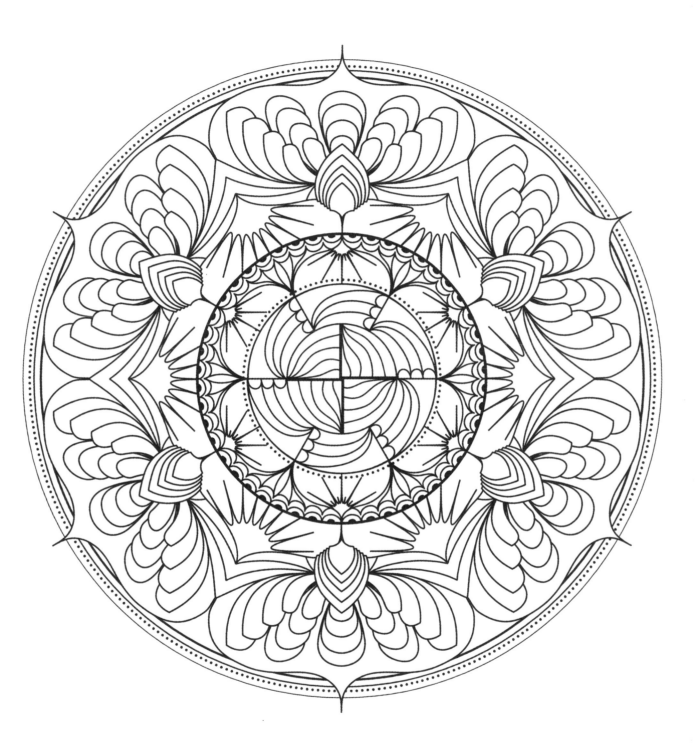

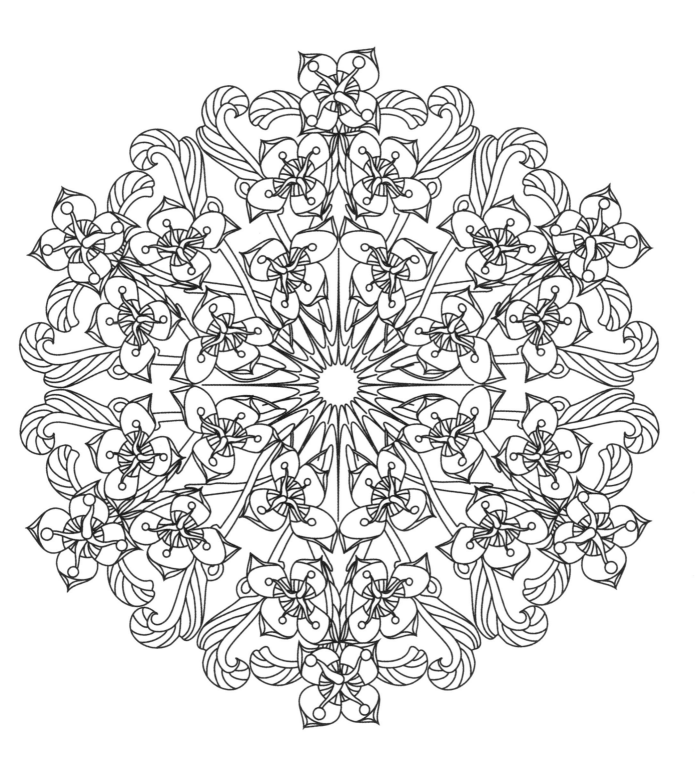

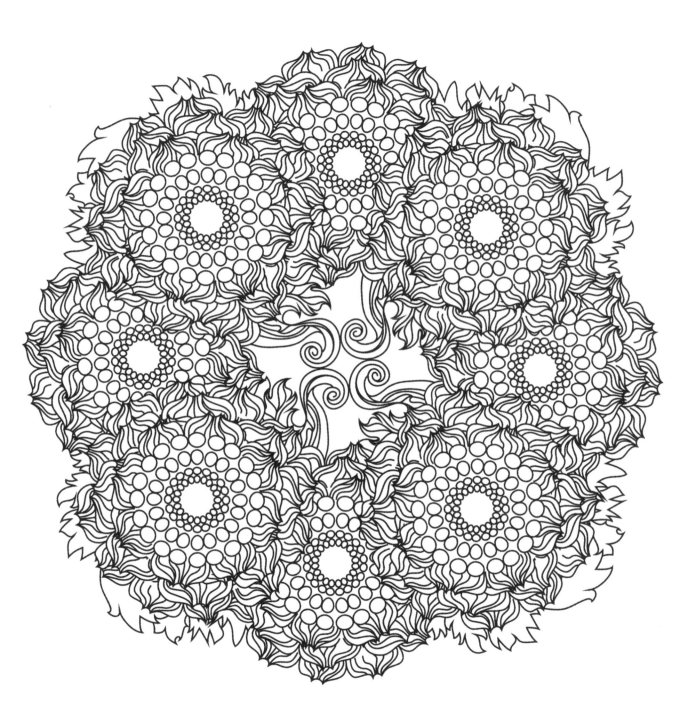

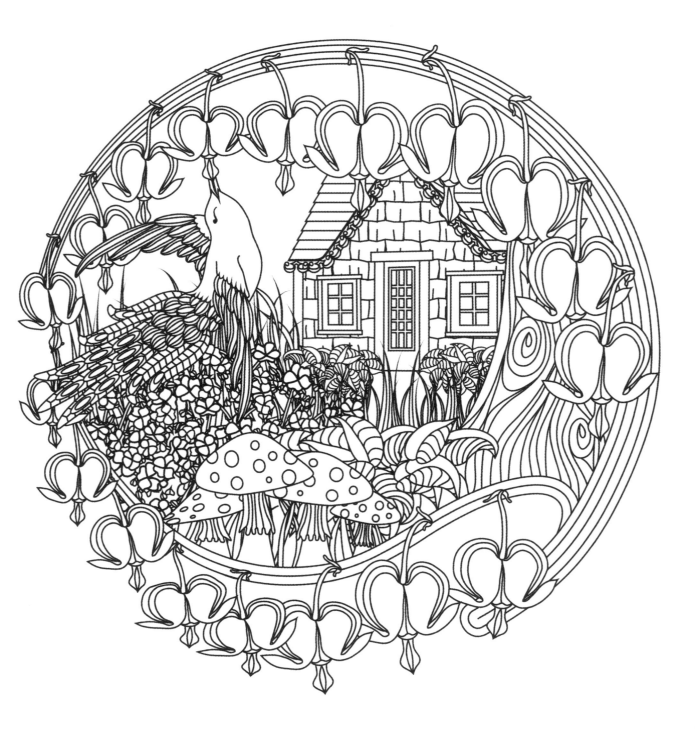

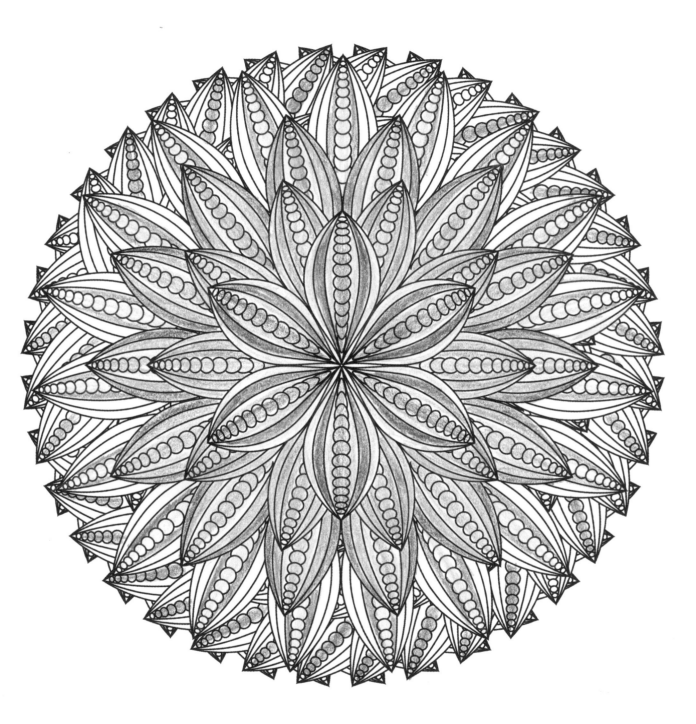

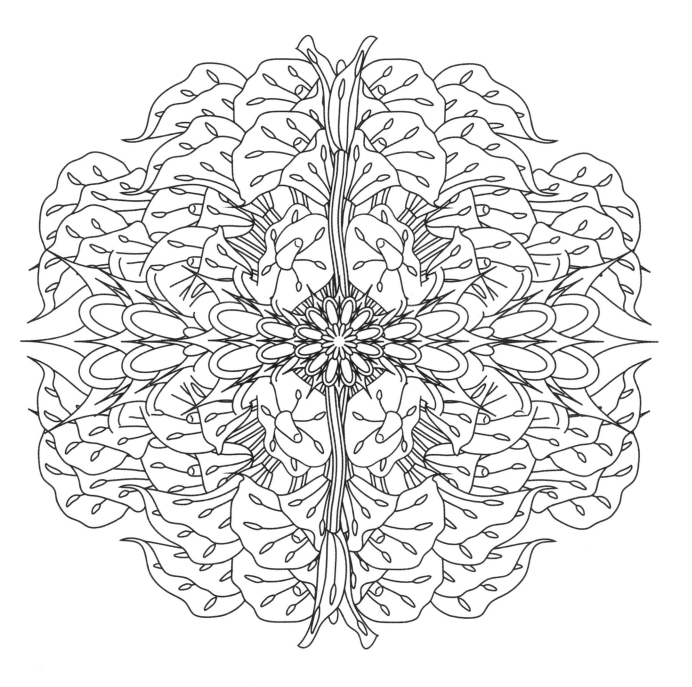

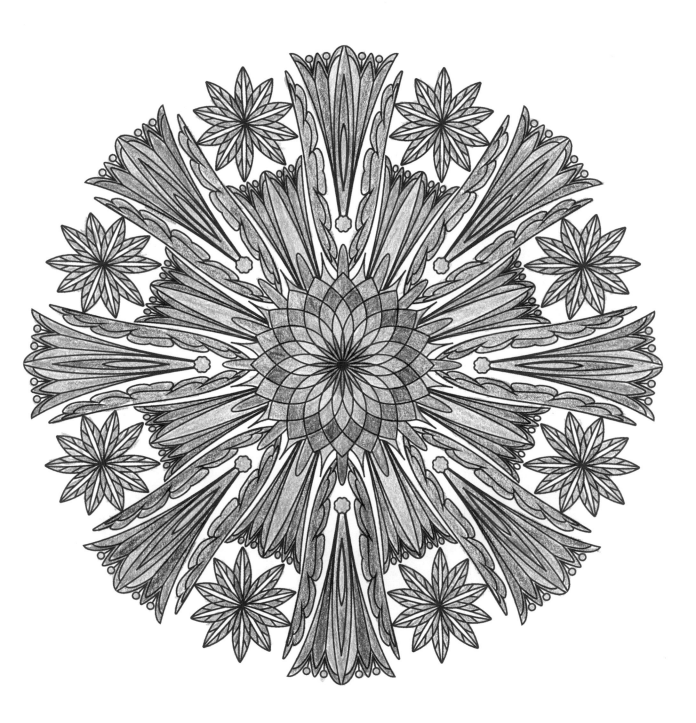

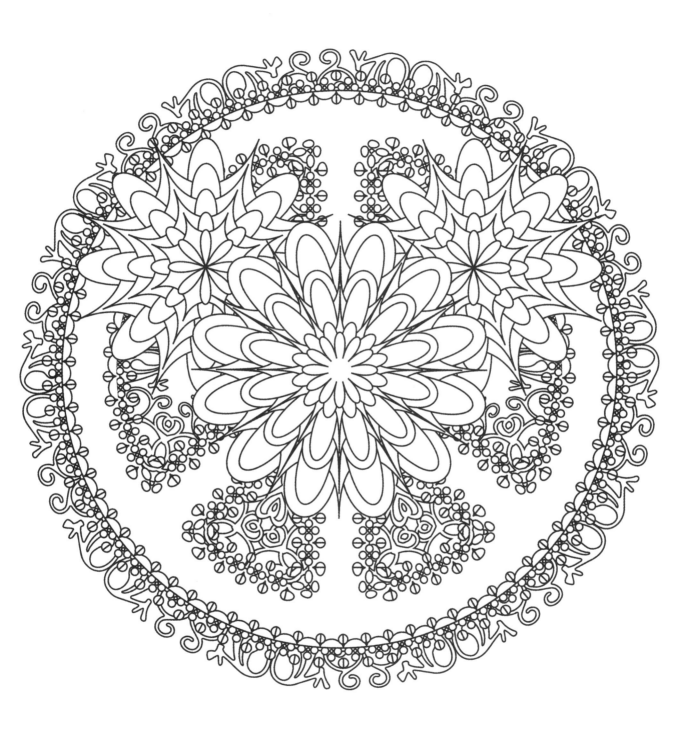

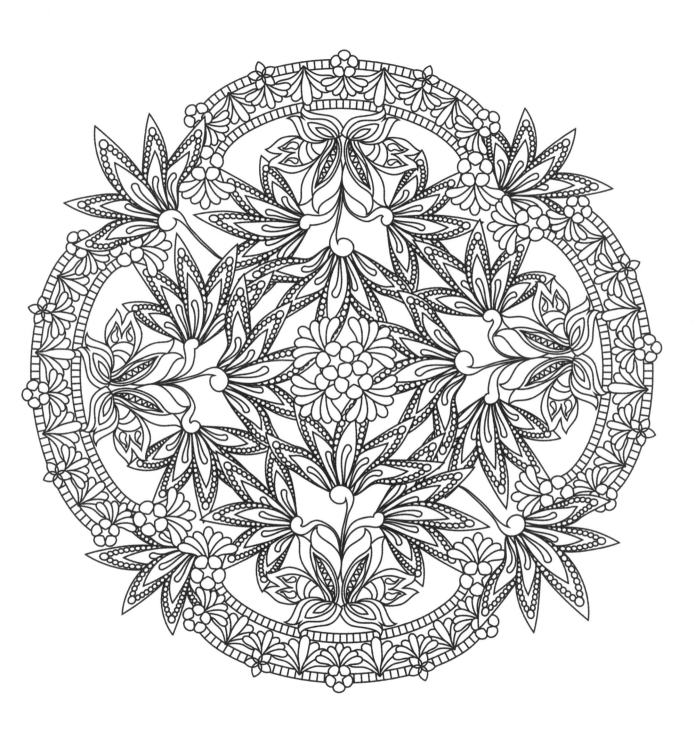

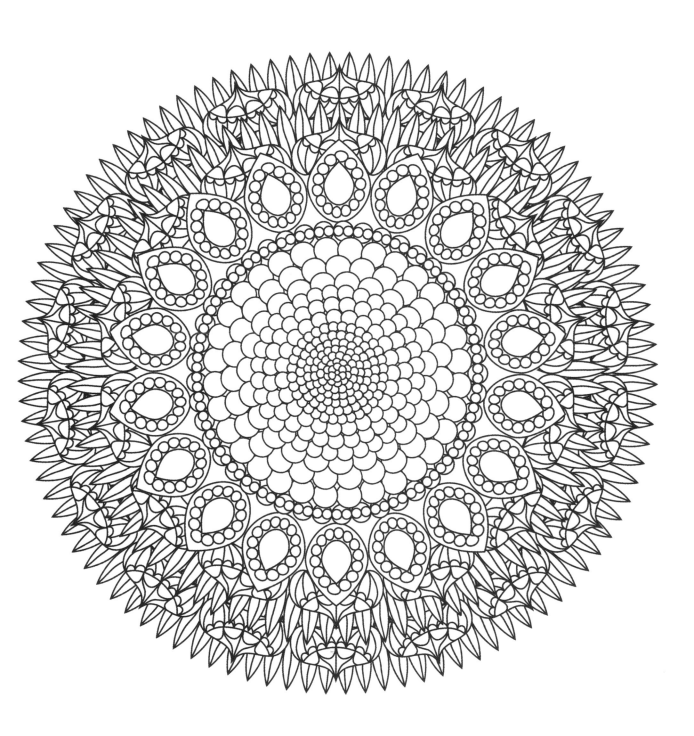

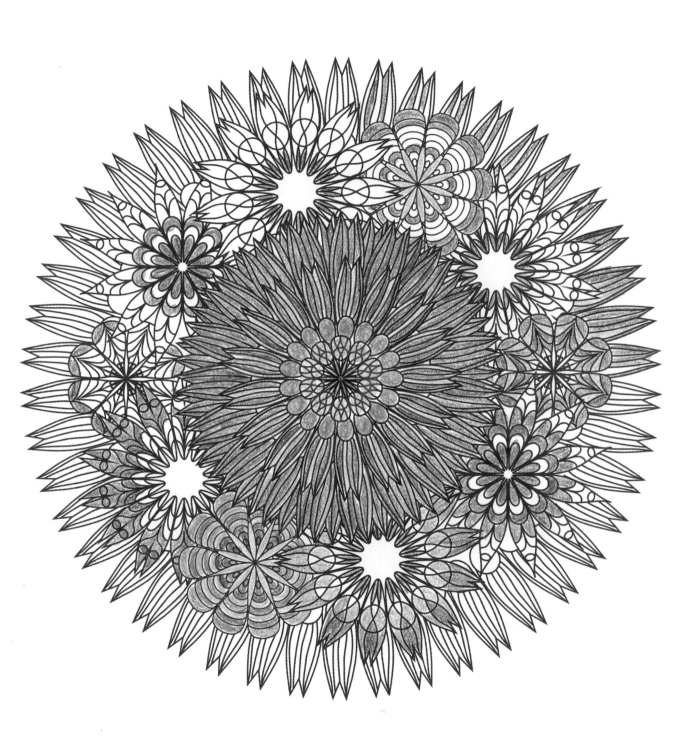

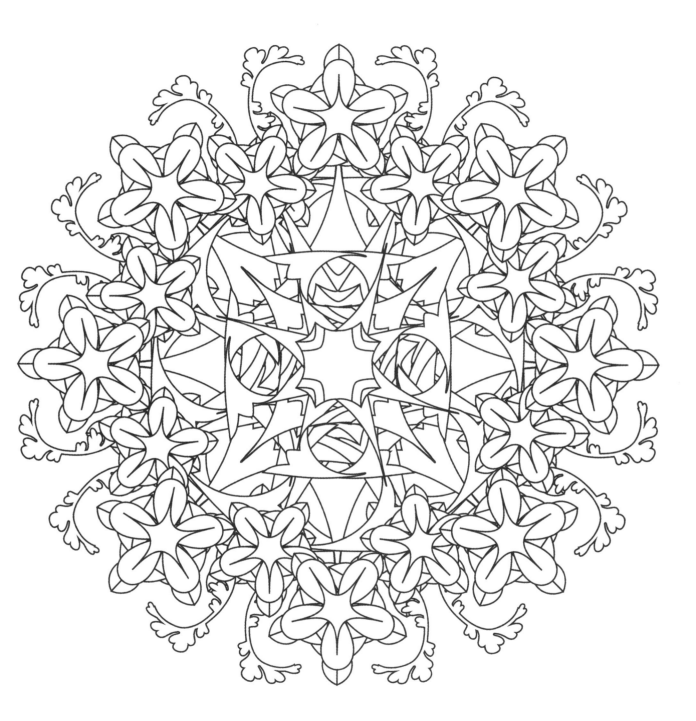

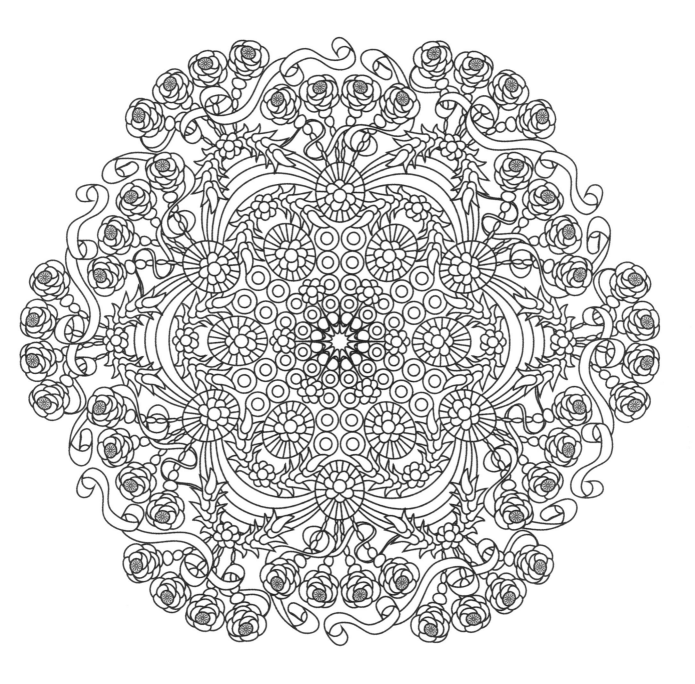

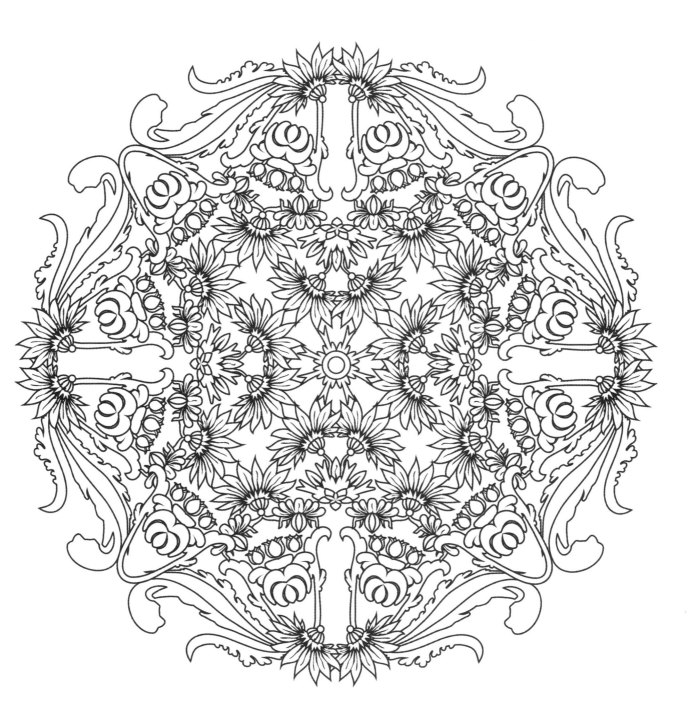

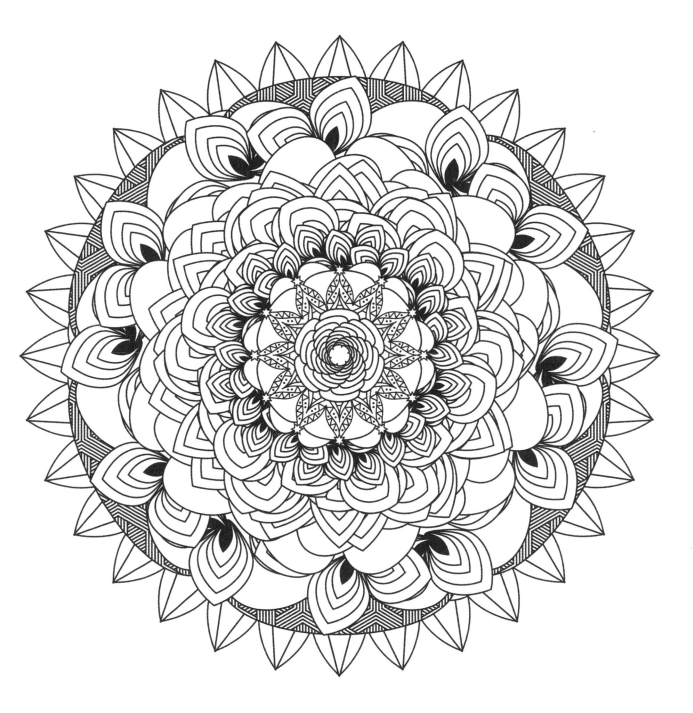

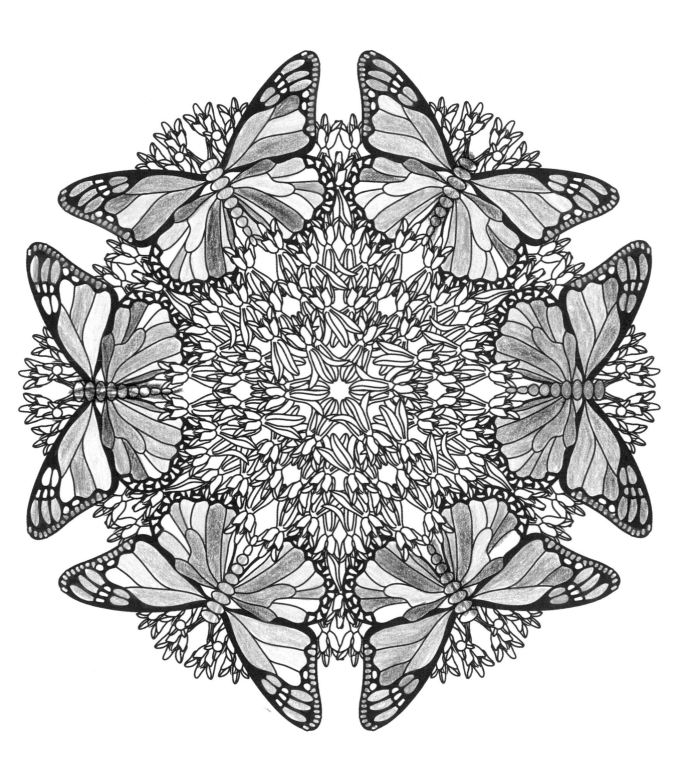

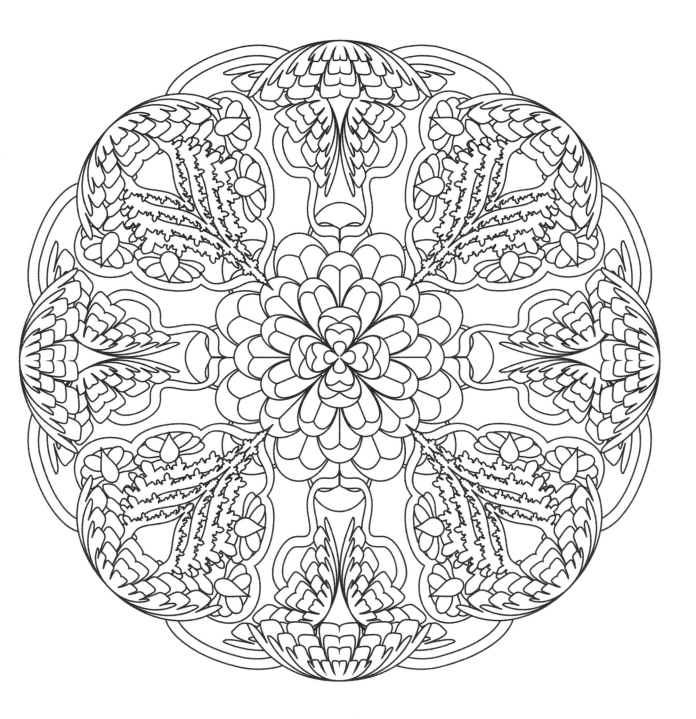

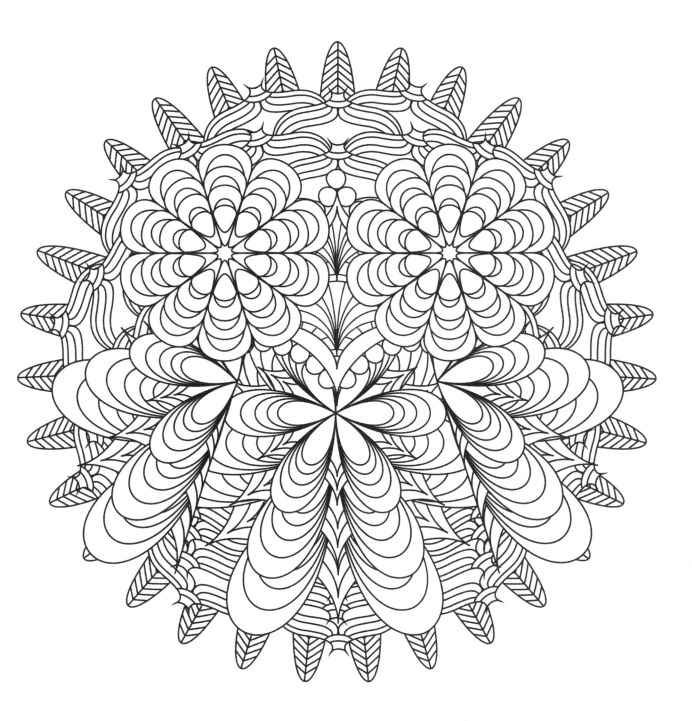

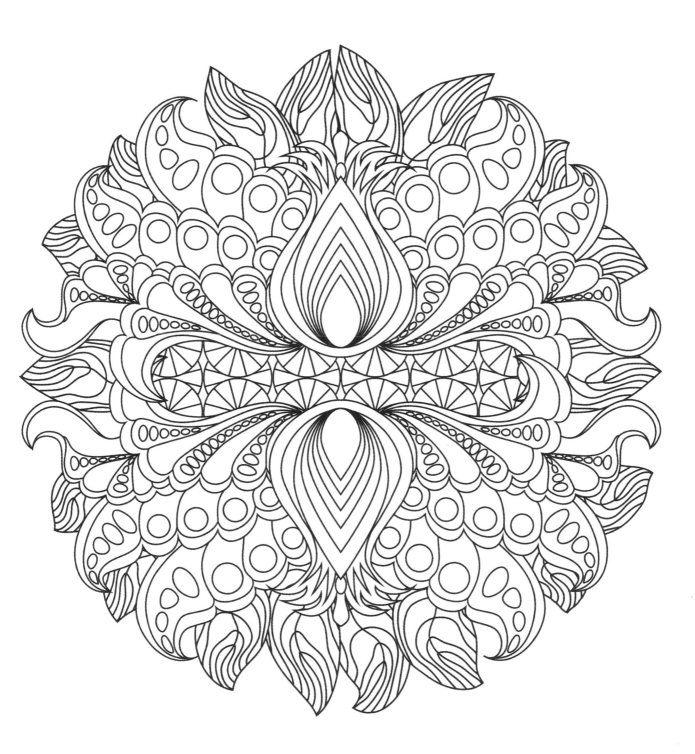

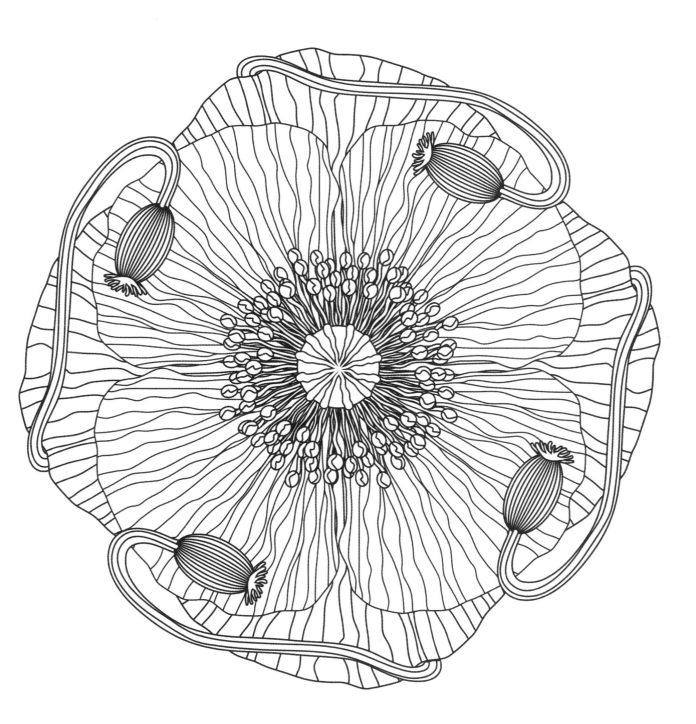

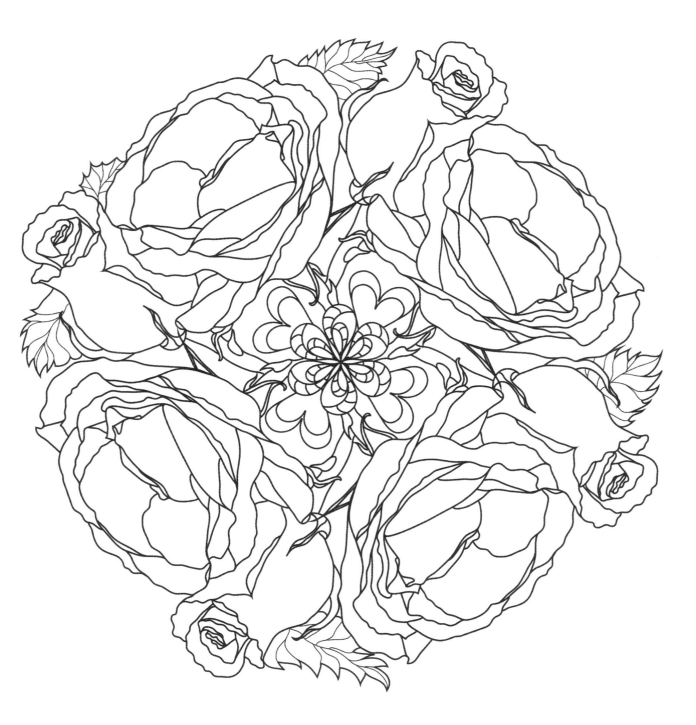

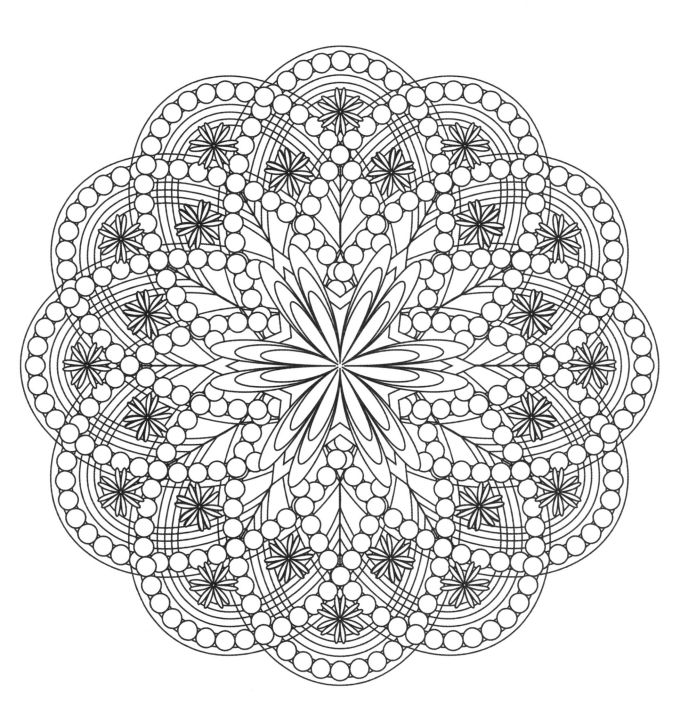

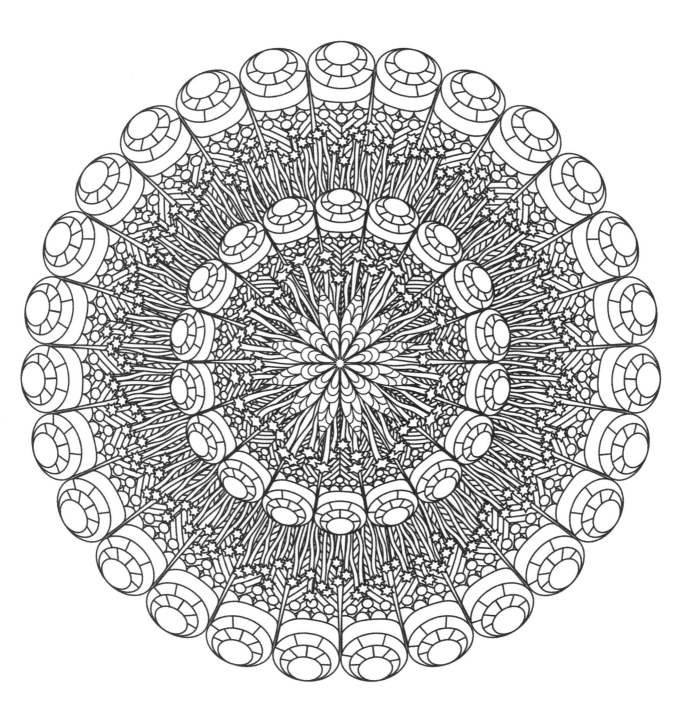

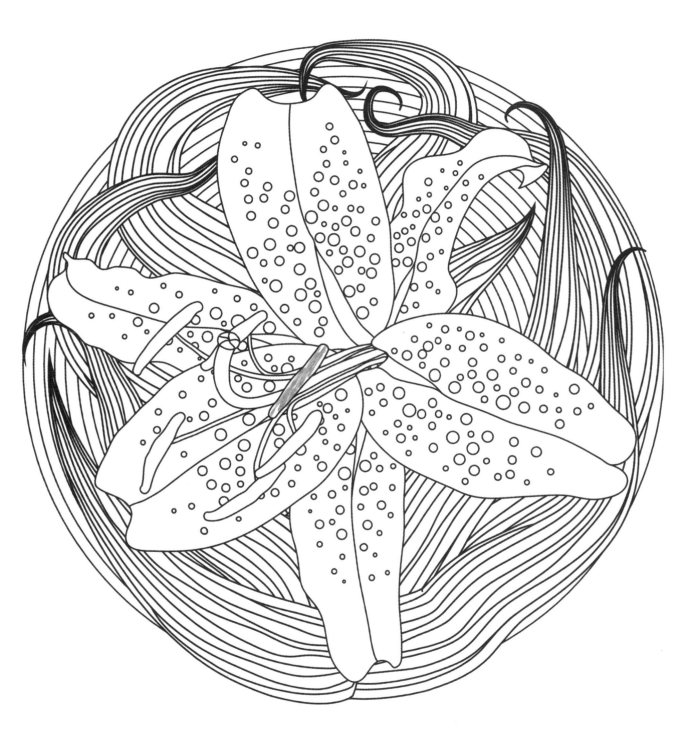

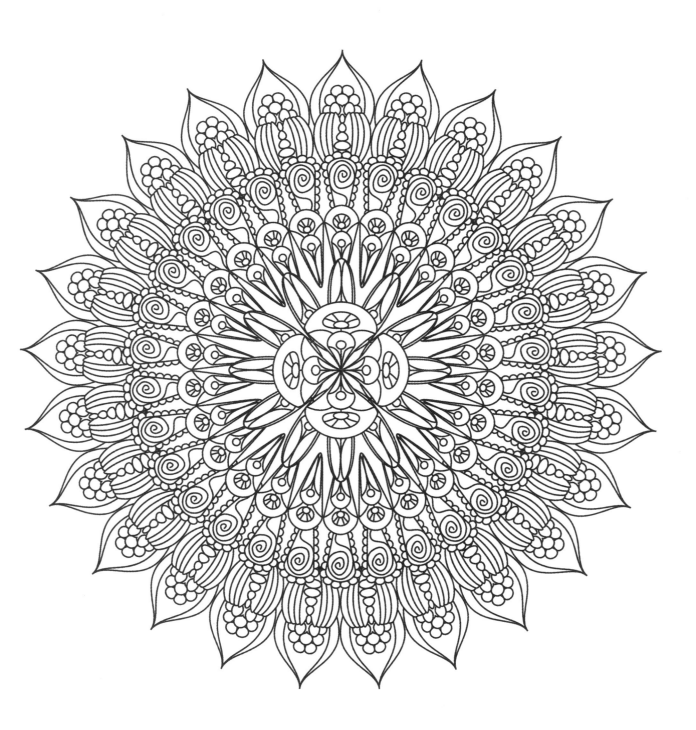

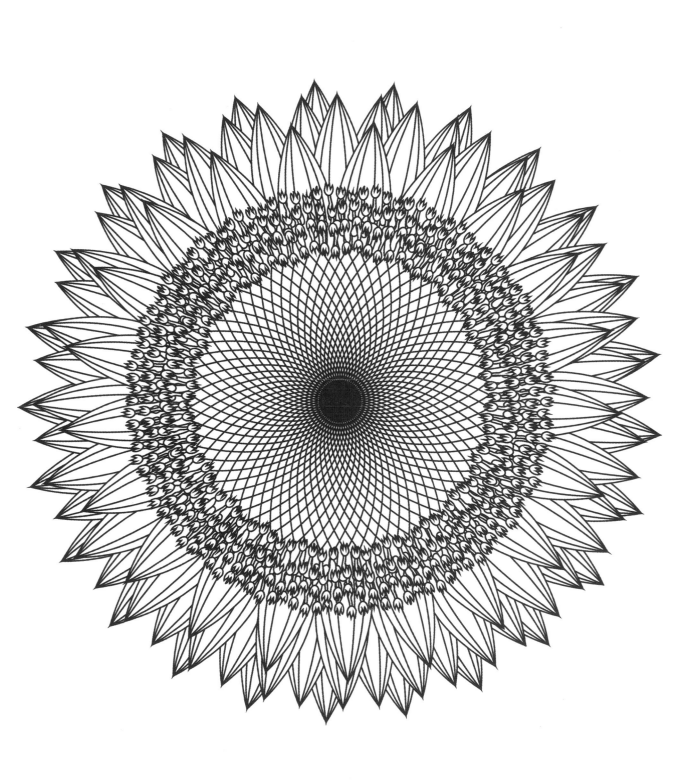

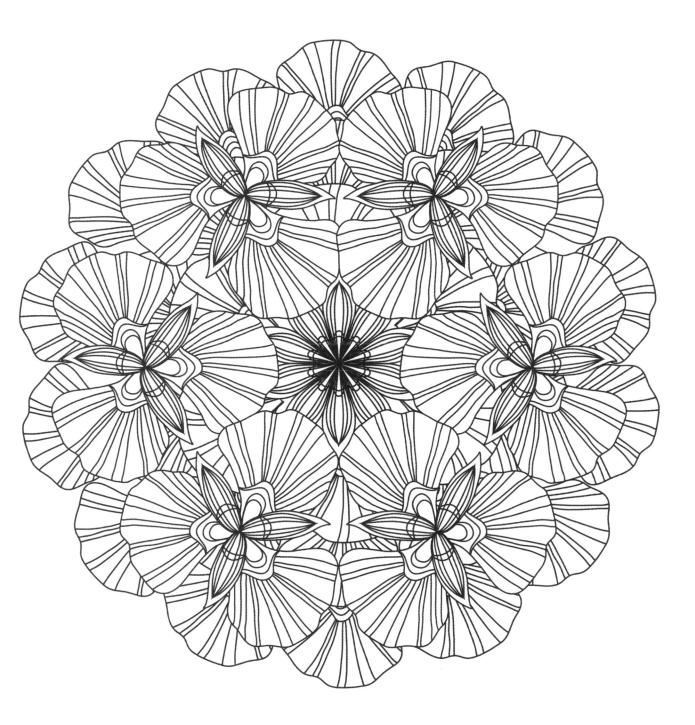

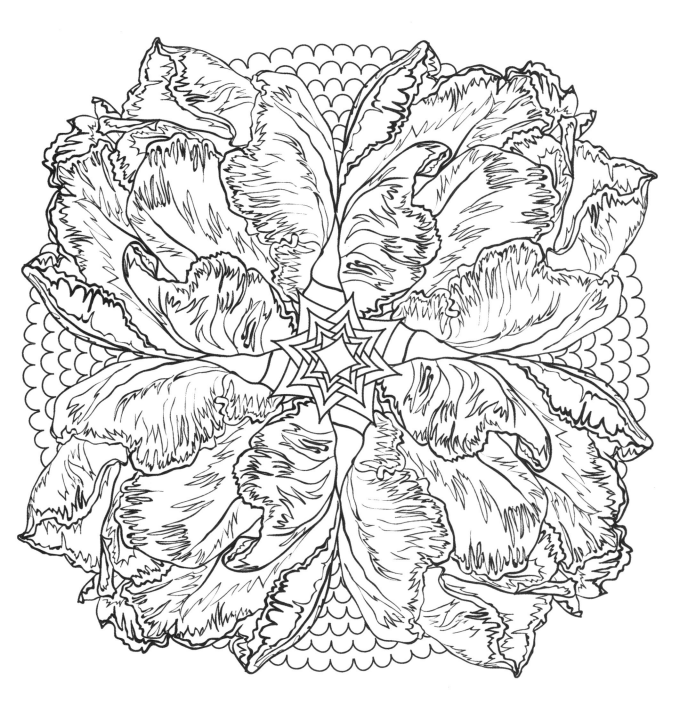

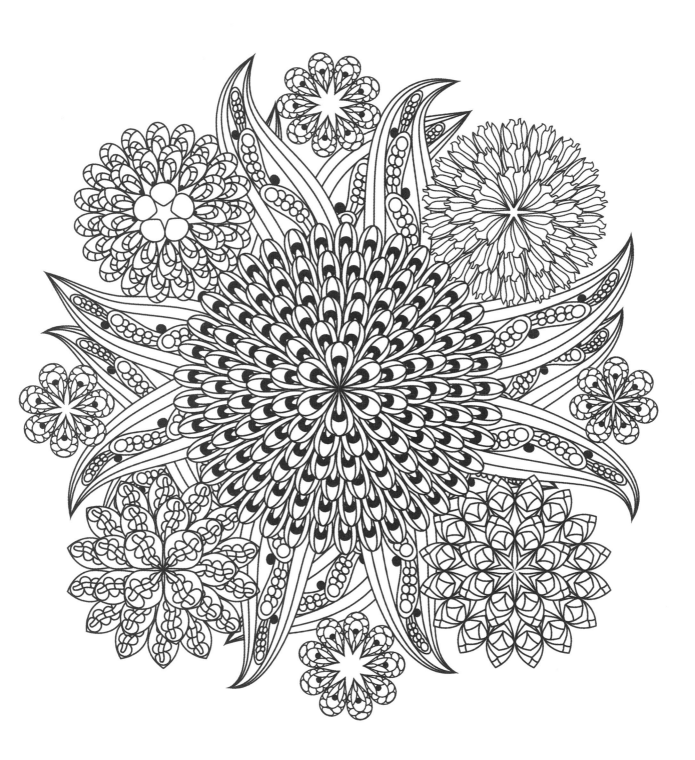

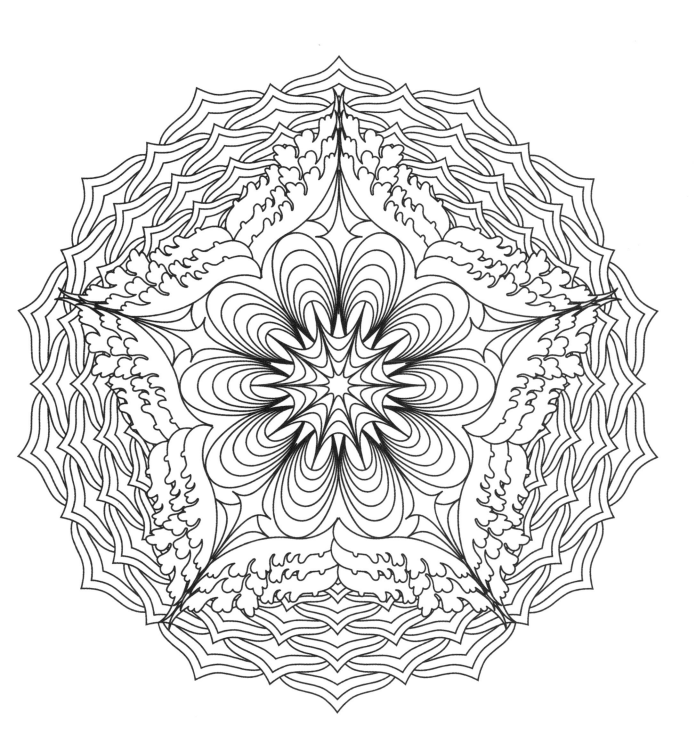

# About the Illustrator

WENDY PIERSALL is a lifelong artist with over 17 years of professional design experience. Author of *Coloring Animal Mandalas*, she has been drawing mandala coloring pages as the founder of the Woo! Jr. Kids Activities website for kids since 2009. She lives with her husband and three children in Woodstock, Illinois.